For Mark Briggs;
the Greatest Art Teacher Ever!

smallfellow press

A division of Tallfellow® Press
Los Angeles

ISBN 1-931290-53-9

2 4 6 8 10 9 7 5 3 1
Printed in the United States of America

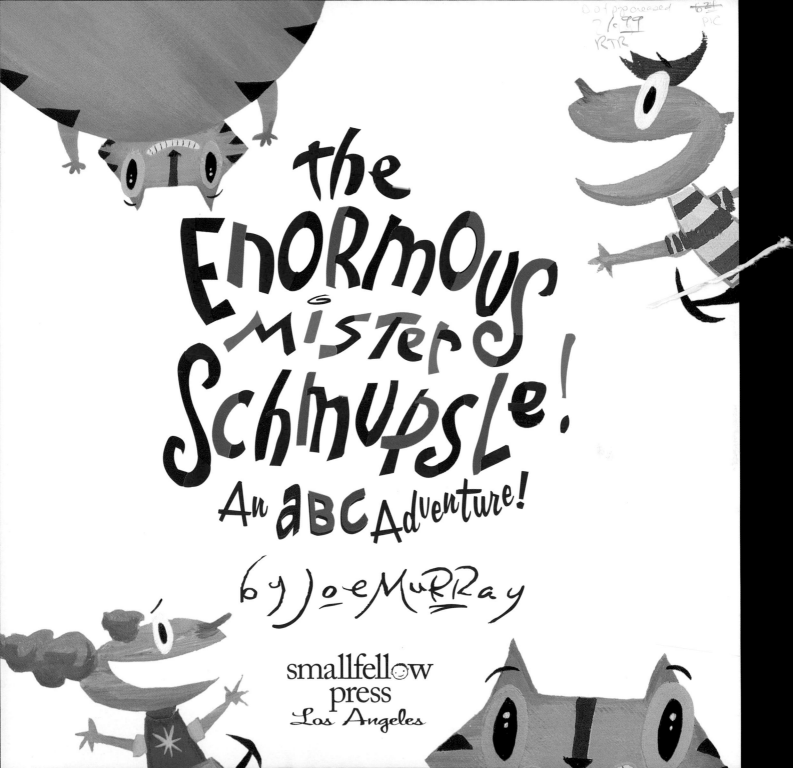

the ENORMOUS MISTER Schmupsle!

An ABC Adventure!

by Joe Murray

smallfell☺w
press
Los Angeles

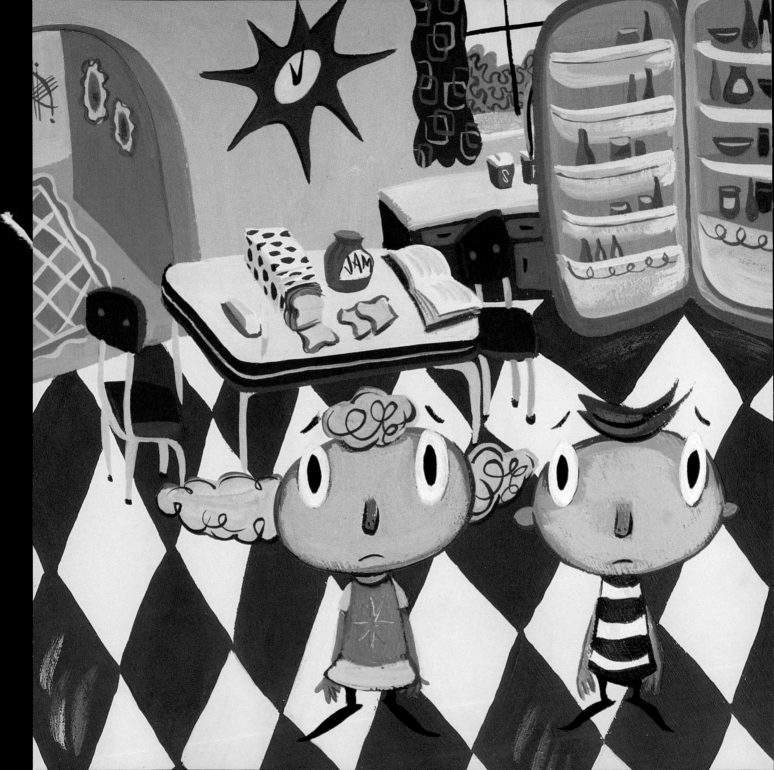

Isaac and his cousin Trixie were hungry.

They had been studying their alphabet for quite some time now, and Aunt Fay and Uncle Snog were still not back from the cheese shop with a snack.

"Let's make an apricot jam and butter sandwich," suggested Trixie. But they had no sooner put the fixings on the table when the doorbell rang.

"Remember, we're not supposed to open the door for strangers," said Trixie.

But it was not a stranger. It was the next-door neighbor, Mr. Rumpskin.

"Children, children, please, please!" Mr. Rumpskin pleaded as he stuck his head through the doorway. "You must, simply must, assist me! I have to leave for the day and my cat can't stop eating. Just can't stop! If you could please watch him for the day and keep him from devouring everything he sees, I would be truly thankful. Truly thankful!"

Isaac and Trixie looked at each other and shrugged. How hard could that be?

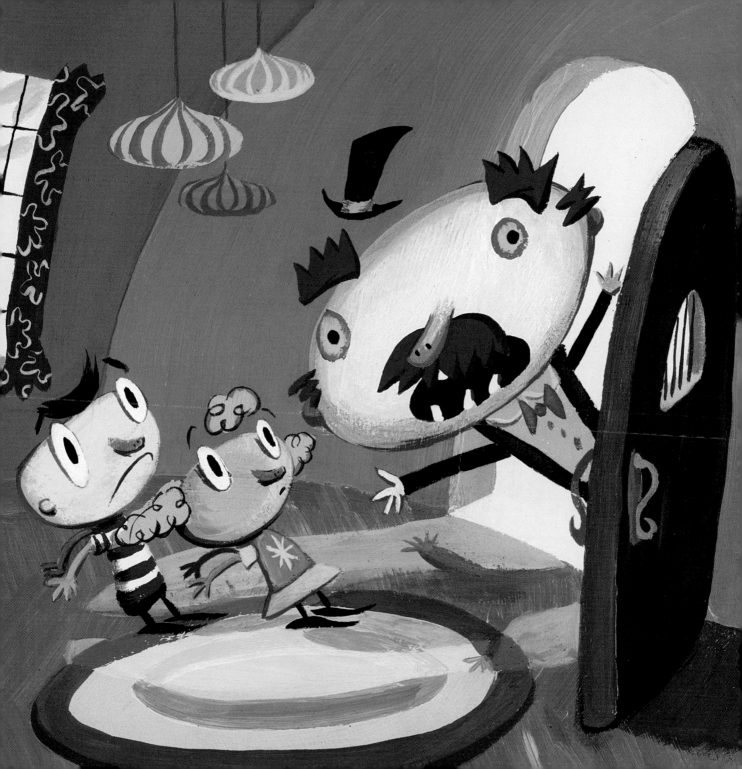

Mr. Rumpskin disappeared for a second. Suddenly Isaac and Trixie saw the enormous rear end of a cat begin to squeeeeeeeze through the door. The mighty feline backside stretched and bent the sides of the doorway with every push Mr. Rumpskin gave. Then, with a loud *POP*, the cat and his rear end catapulted into the house, bouncing off the walls like a giant rubber ball.

BOING! BOING! ZING! ZONG! ZOOP !

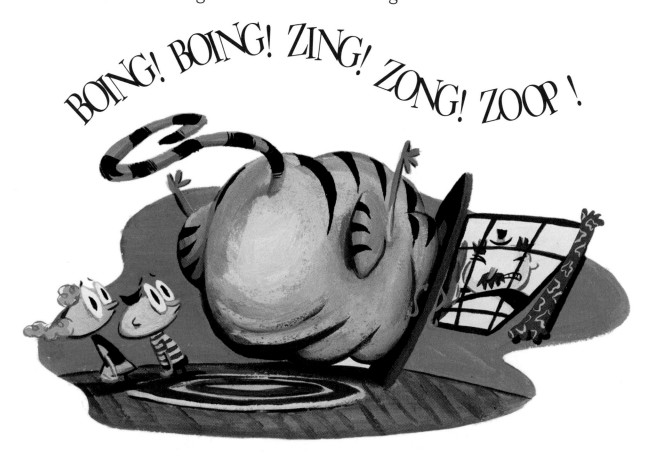

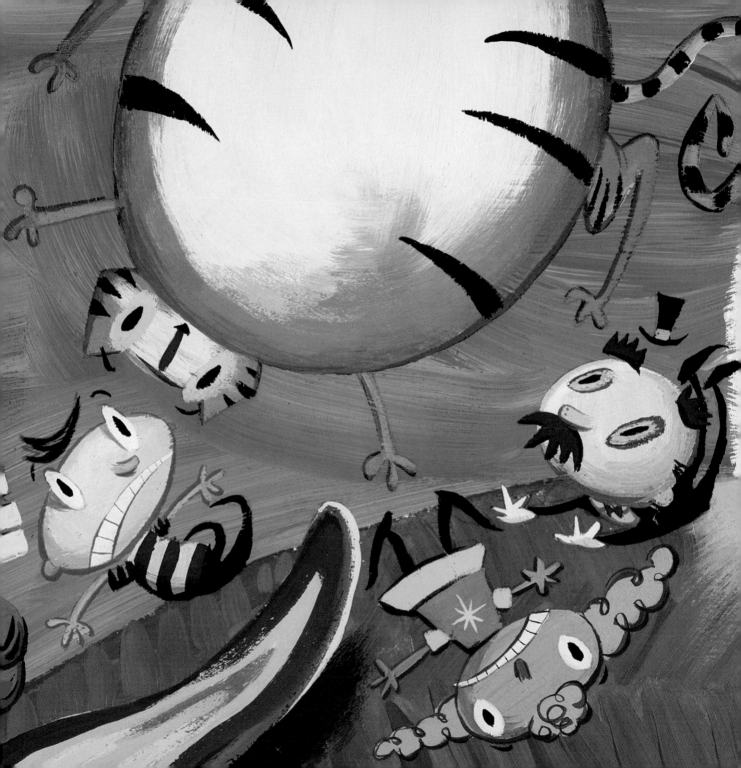

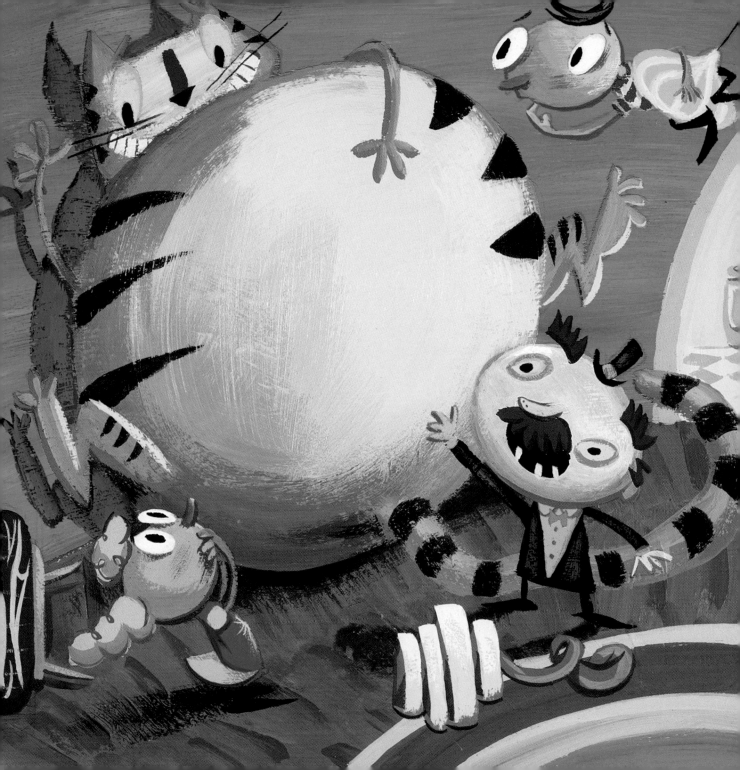

When the house stopped shaking, Isaac and Trixie found themselves staring at the FATTEST cat they had ever laid eyes on!

"This…" panted Mr. Rumpskin, "…is Mr. Schmupsle! That's Shhhhh as in quiet, Mup, and Sell, as in SELL toasters! SCHMUPSLE! Make sure Mr. Schmupsle gets water, but no more food! No more food! He has been expanding like this for the last three weeks!"

"We will try," Trixie replied. "But we are supposed to be studying our alphabet!" Unfortunately, Mr. Rumpskin did not hear Trixie. He was already running down the street.

Seconds after Isaac and Trixie closed the front door, they heard a large gulping sound coming from the kitchen.

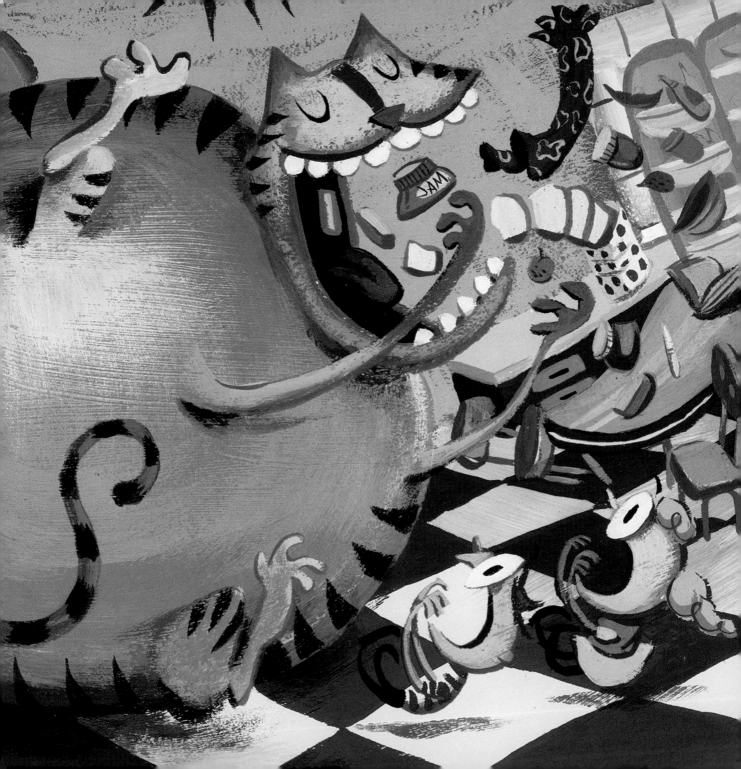

"Mr. Schmupsle's eating!" they both yelled. Isaac and Trixie ran into the kitchen just in time to see the cat gulping down the last of the apricot jam and five sticks of butter!

"We need to get this cat outside. There is too much to eat in this house!" yelled Isaac.

"But we promised we would study," said Trixie. "If Uncle Snog and Aunt Fay come home and we are not studying the alphabet, Aunt Fay may force us to eat her curious meatloaf!"

Isaac grunted as he pushed a wagon beneath Mr. Schmupsle's belly. "Well, **A** is for apricot jam and **B** is for butter. Isn't that learning our alphabet?"

"Hmmmmm," Trixie answered. "I guess so."

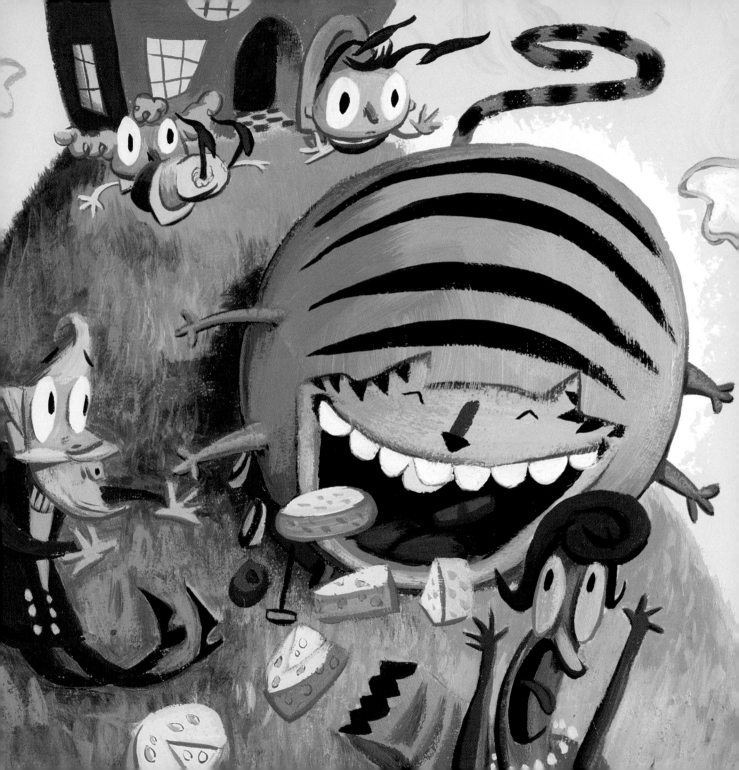

Isaac and Trixie gave a hard push to roll Mr. Schmupsle out the back door. But they pushed a little too hard. Mr. Schmupsle continued rolling, and rolling, and rolling still! Isaac and Trixie grabbed on to his tail just as he crashed into Aunt Fay and Uncle Snog returning from the cheese shop. But this did not slow Mr. Schmupsle down. Oh, no. In one gulp, he finished off all of Aunt Fay and Uncle Snog's cheese, and kept right on rolling!

"**C** is for cheese!" yelled Isaac and Trixie as they flew past their aunt and uncle.

"Quite unusual," murmured Uncle Snog. "I had no idea cats fancied Chippewa cheddar."

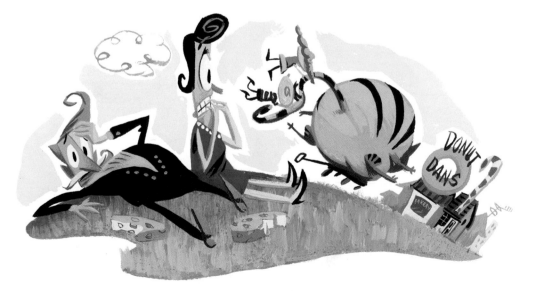

With all of their might, Isaac and Trixie pulled themselves up onto Mr. Schmupsle's back as he careened down the hill, heading straight for Donut Dan's Bakery.

Schwoooooosh! went the cat and the kids through the bakery door. The astonished customers flew out of the way, holding on to their prized pastries.

"Take a number!" yelled Donut Dan. But Mr. Schmupsle did not. Instead, he swallowed ten dozen glazed old-fashioned donuts and two dozen eclairs! Then he rolled on, into Peppermint Pete's Candy Shop!

"**D** is for donuts!" yelled Isaac and Trixie. "**E** is for eclairs! **F** is for fudge! **G** is for gumballs!"

"This is fun!" Trixie chuckled. They had given up on keeping Mr. Schmupsle from eating. Now they were on for the ride!

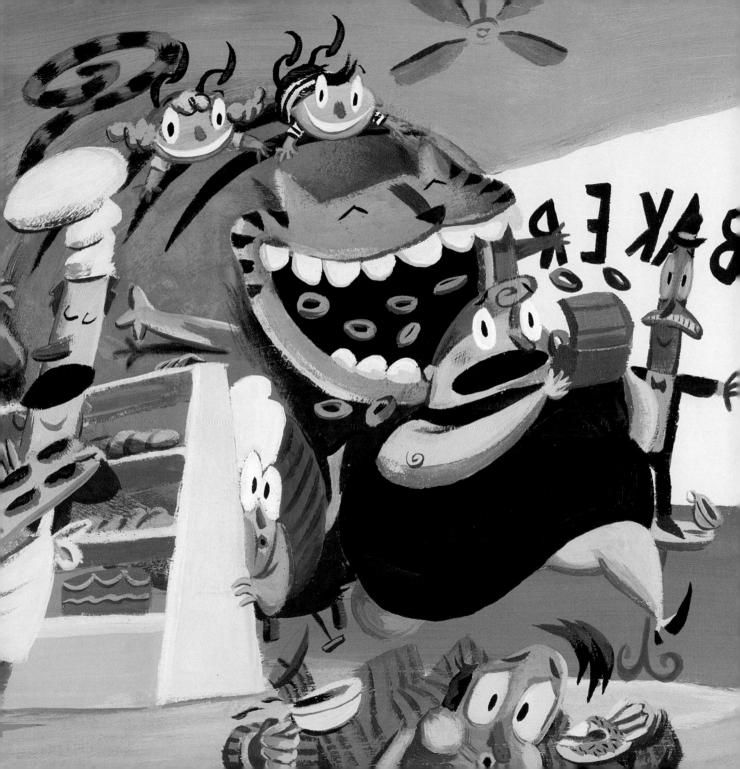

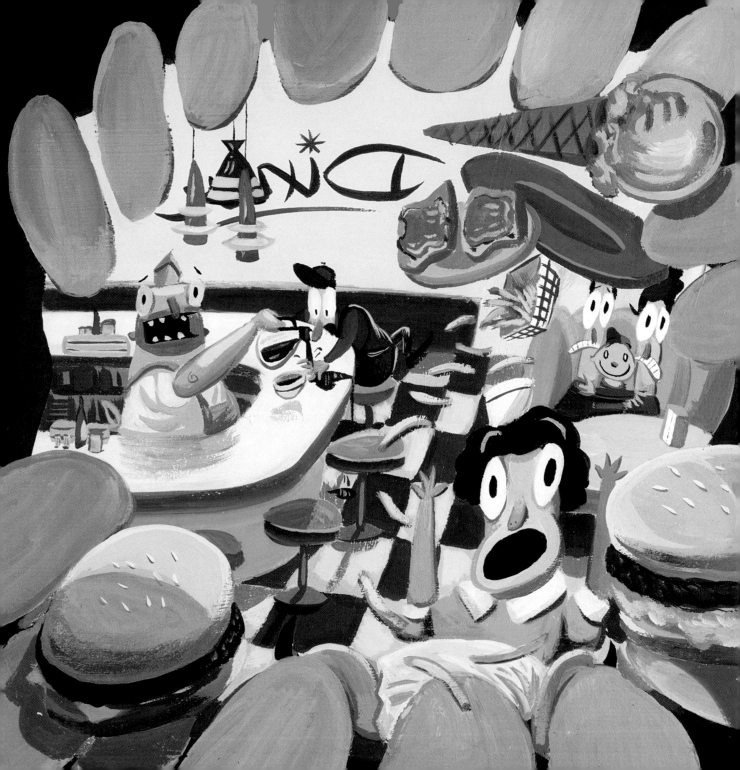

Mr. Schmupsle had no sooner swallowed the last gumball when he and his passengers burst into Stinky Stanley's Diner! **POW!** went Mr. Schmupsle, right into the poor waitress bringing lunch to the Pinkwinkle family!

The waitress screamed as she stared into the gaping mouth of the very hungry cat.

"**H** is for hamburgers!" Isaac grimaced. "**I** is for ice cream!" Trixie smiled, smacking her lips!

"**J** is for jelly toast and **K** is for... **K** is for..."

The kids were shocked! Mr. Schmupsle gobbled right past the letter **K**. But they had little time to think about that. Mr. Schmupsle continued down the hill toward Mustachio Tony's Italian Eatery!

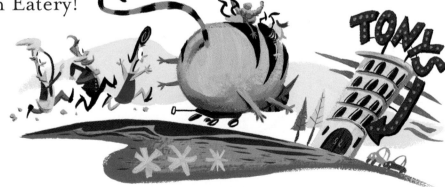

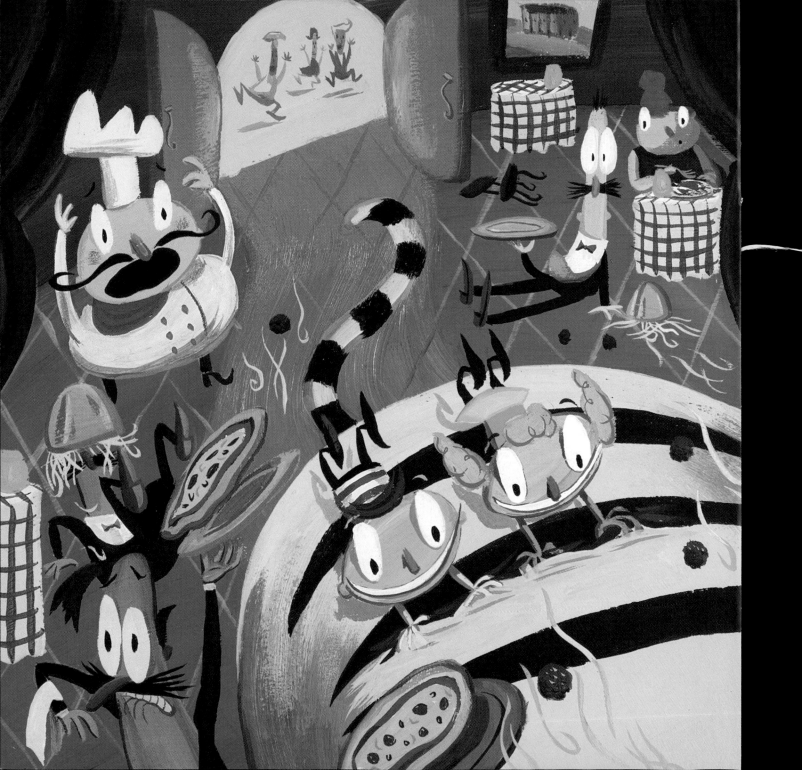

"**L** is for lasagna!" the kids continued.

"**M** is for meatballs!

"**N** is for noodles!

"**O** is for olives!

"**P** is for pizza!

"**Q** is for quiche!"

Isaac and Trixie looked at each other.

"Is quiche Italian?" asked Isaac.

"Italian quiche is!" said Trixie.

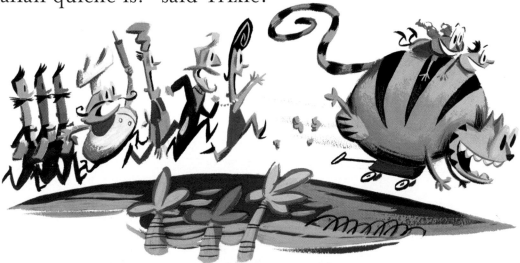

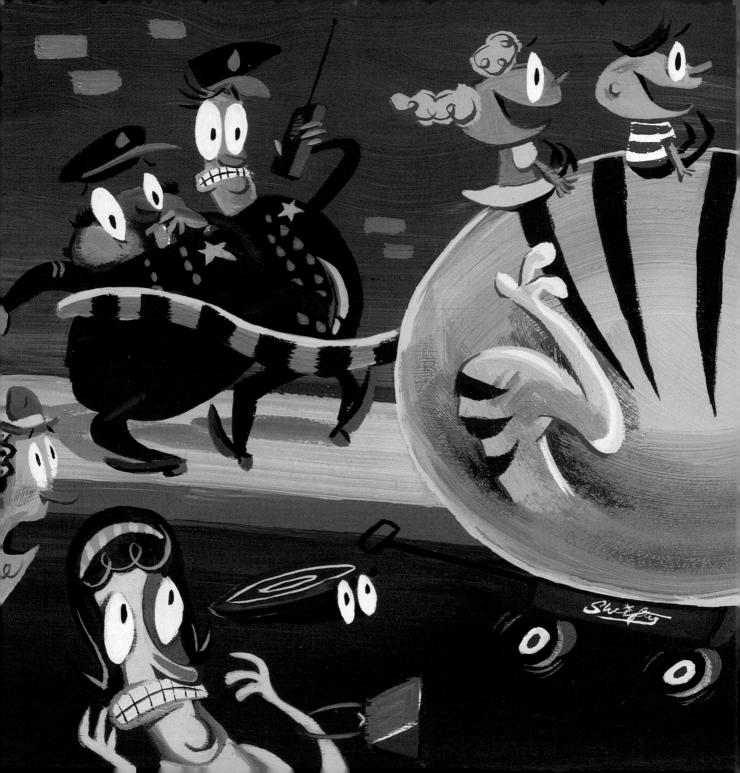

Tweeeeeeeeeeeeeeet! went a whistle as

two police officers jumped back onto the curb just in time to watch two giggling children and an enormously overweight cat fly by on a wagon!

"Unidentified speeding…I mean feeding…I mean A BIG FAT CAT is heading right for the outdoor farmers market!" yelled one of the officers into his radio.

"**R** is for raspberries!" Trixie announced.

"**S** is for strawberries!" Isaac responded.

"And **T** is for tomatoes! **U** is for ugli fruit! **V** is for vegetables! And **W** is for watermelon!"

"Still no letter **K**!" yelled Trixie.

As Mr. Schmupsle sped closer to the bottom of the hill, the more he ate, the faster he went!

"**X** is for xigua melon!" Isaac and Trixie yelled, now holding on with all of their might!

"**Y** is for yams!" they grimaced, straining with each word.

"And… **Z**… **z**…is…for…Zucchini!"

Just as the words left their lips, Mr. Schmupsle went flying over a bump, sending him high into the air and leaving Isaac and Trixie far behind.

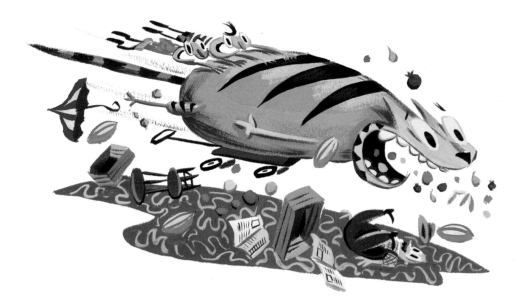

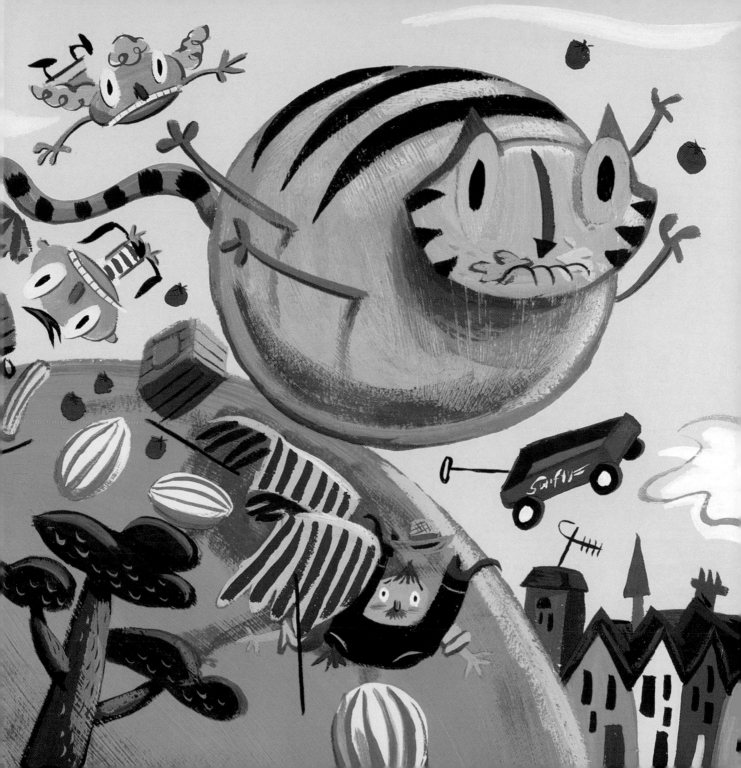

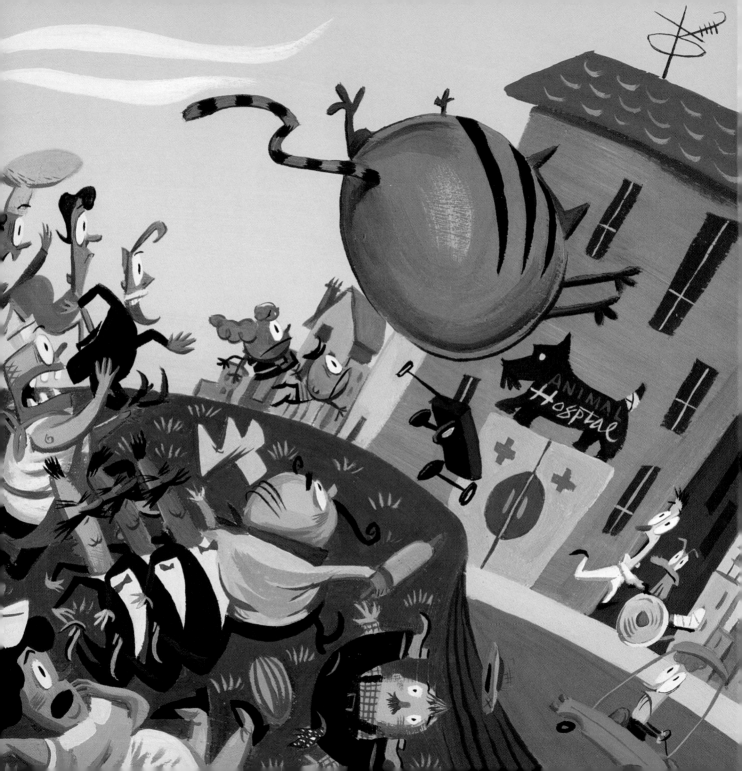

The crowd that had been chasing the cat skidded to a halt at the top of the bump just in time to watch Mr. Schmupsle fly through the air like a jumbo parade balloon.

KaaaaaaaaBooooooooom! went

the cat, crashing through the front doors of the animal hospital at the bottom of the hill.

After the dust settled, everyone was quiet. All that could be heard was the *squeak*, *squeak*, *squeak* of a spinning wheel coming to a stop on the overturned wagon.

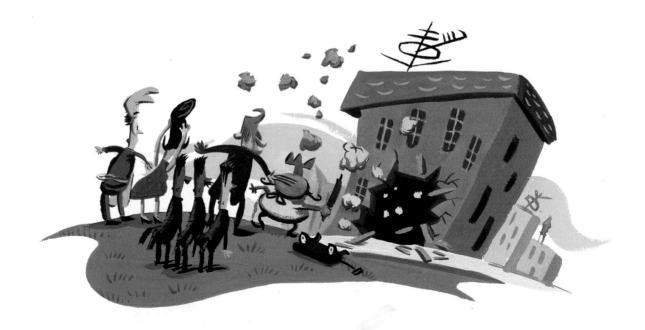

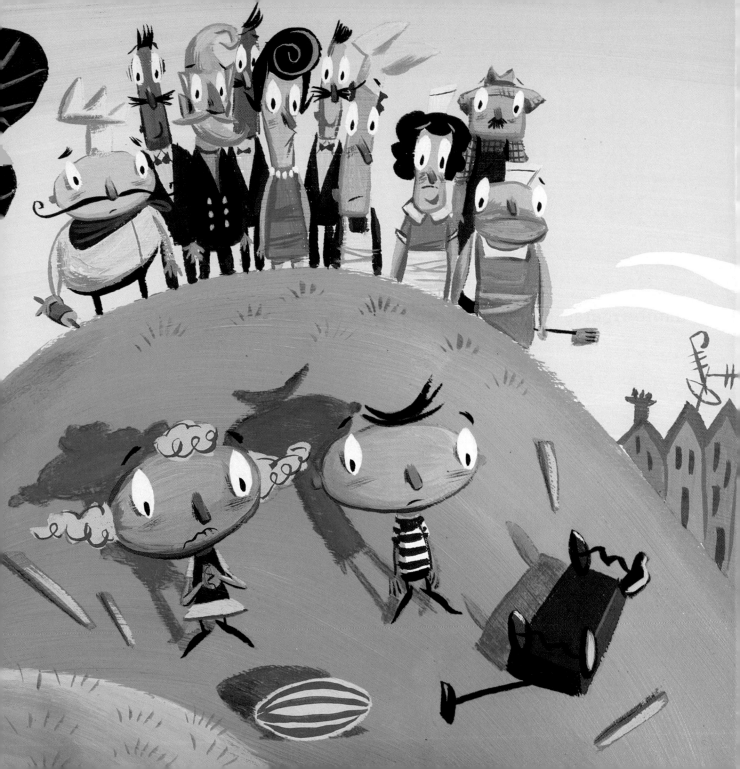

Standing there, staring at the hole in the hospital doorway were Trixie, Isaac, Aunt Fay and Uncle Snog. There was Donut Dan, Mustachio Tony and everyone else who had watched their food disappear into Mr. Schmupsle's belly. But where was Mr. Schmupsle?

After a long pause, a doctor came to the doorway with a grim look on his face. He pulled down his surgical mask and announced: "I must inform you..."

"Yeeeeessssss?" everyone asked, as they leaned forward to hear.

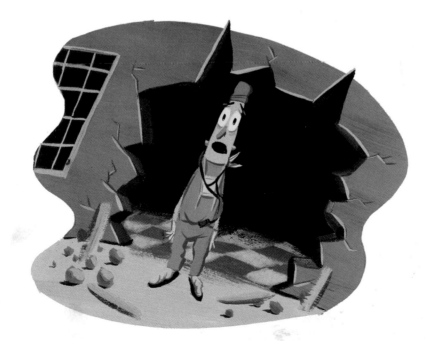

"...that K is for kittens! All 132 of them!"

"Huh?" the crowd murmured. Then, after a moment of quiet, everyone erupted into a cheer! "HOOOOORAYYY FOR MR....eh...er...MRS. SCHMUPSLE!"

"So you see, Mr. Schmupsle was really Mrs. Schmupsle," Trixie chuckled.

"And Mrs. Schmupsle was doing all of this eating and growing because she was going to be a mommy," Isaac added.

"And Mrs. Schmupsle likes Chippewa cheddar!" added Uncle Snog. "And that is quite unusual because it is a rather smelly cheese!"

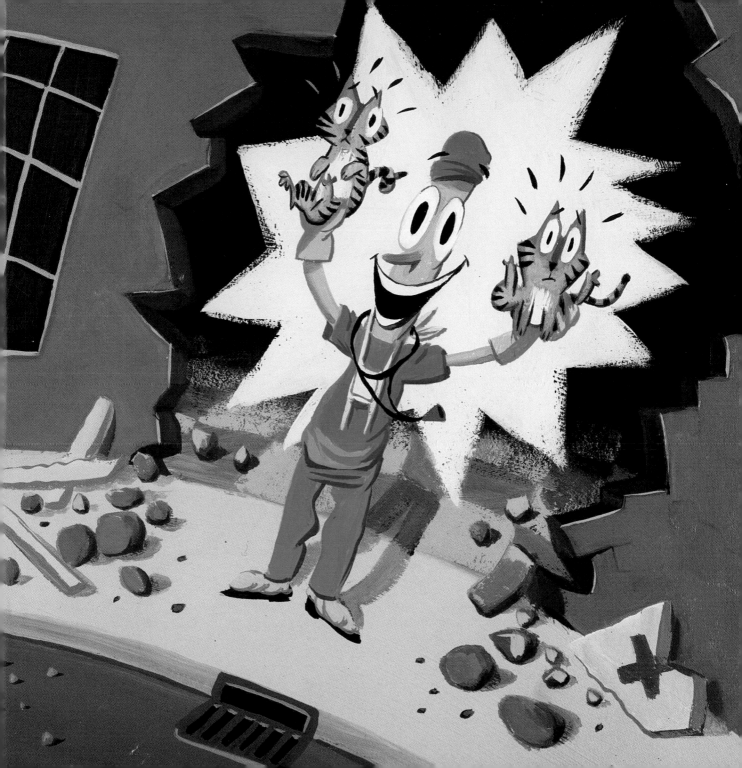

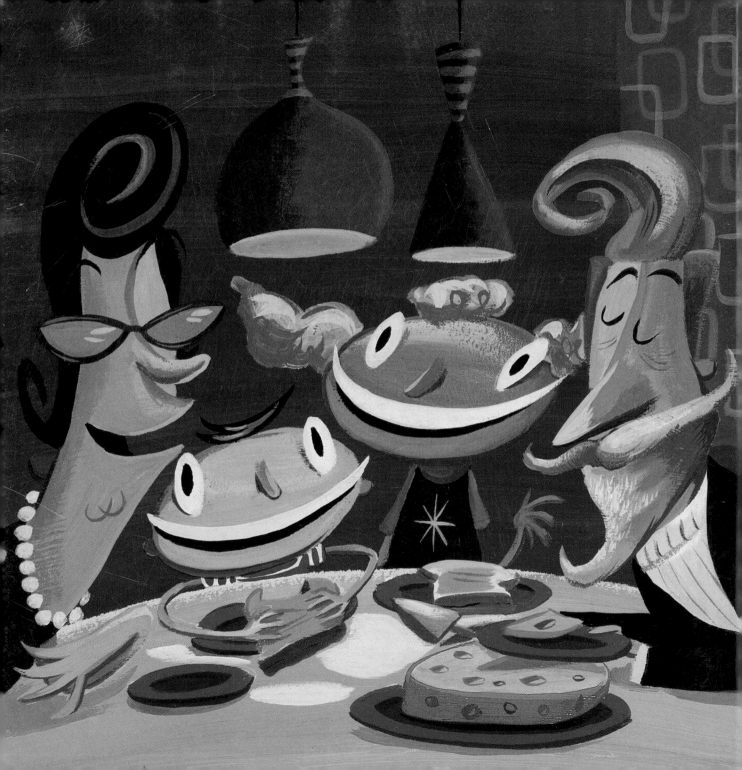

"So after Mrs. Schmupsle returned to her normal size, Mr. Rumpskin promised kittens to everyone who lost food due to Mrs. Schmupsle's appetite," said Trixie.

"And we got the rest," Isaac smiled, as he bit into his apricot jam and butter sandwich. "Boy, was Mr. Rumpskin grateful to us for getting Mrs. Schmupsle to the hospital on time!"

"Well," smiled Aunt Fay, "that was quite a story. And quite an inventive way to study your alphabet like you promised. But I have two questions…

"What are we going to do with all of the kittens Mr. Rumpskin gave us? And what is a xigua melon?"

"I don't know," answered Trixie. "But after the kittens finish nursing from their mommy, we can always feed them Chippewa cheddar. Because cats love it!"

"And that is unusual," said Uncle Snog, "because it is a rather smelly cheese."

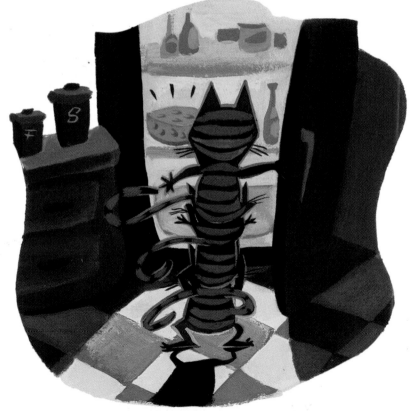

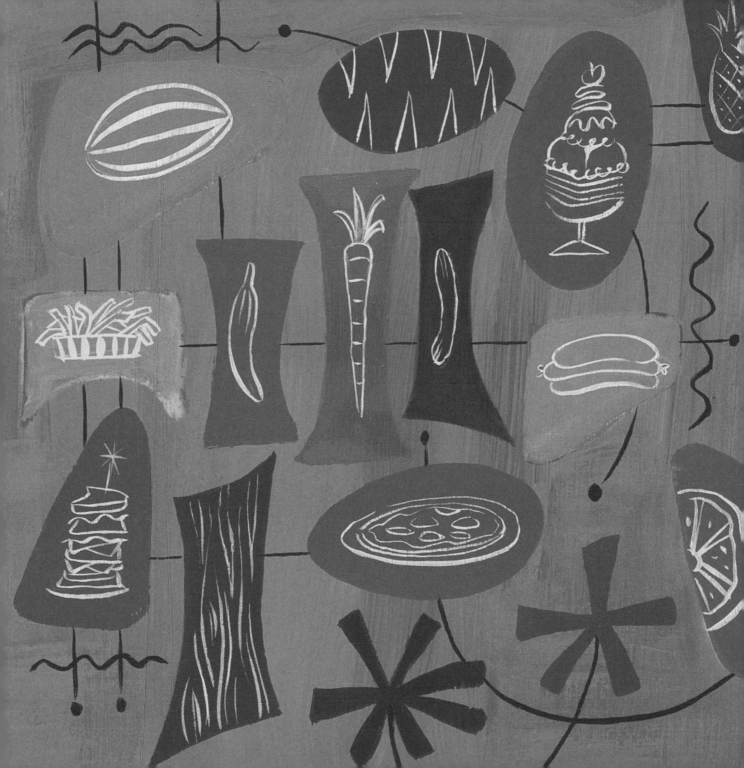

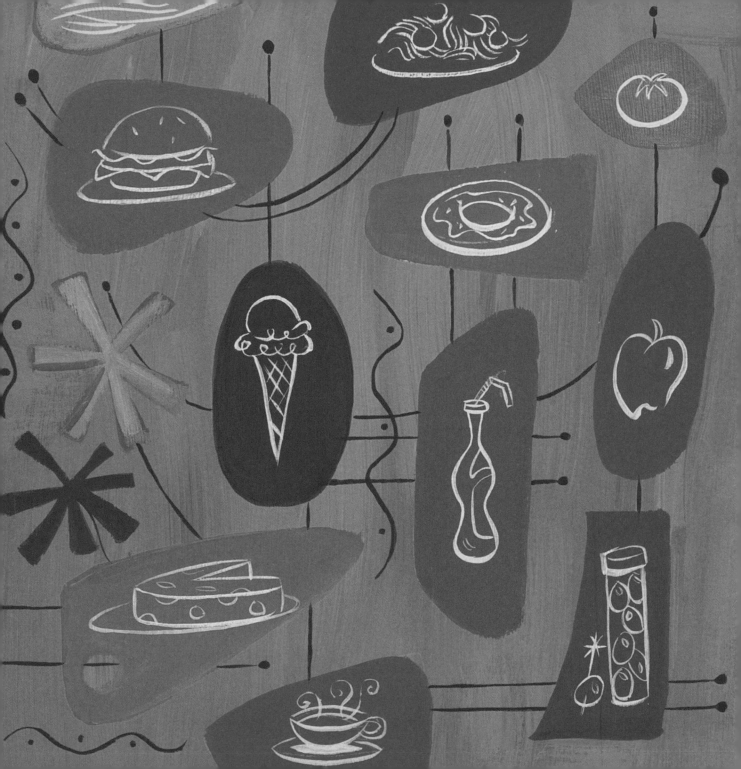